Ten Days in India

a sketchbook from my travels in Tamil Nadu
in March 2012

to see more of Robert Markey's artwork go to
robertmarkey.com

Copyright © 2013 Robert Markey
Cover Design by Robert Markey
ISBN 978-1484957127

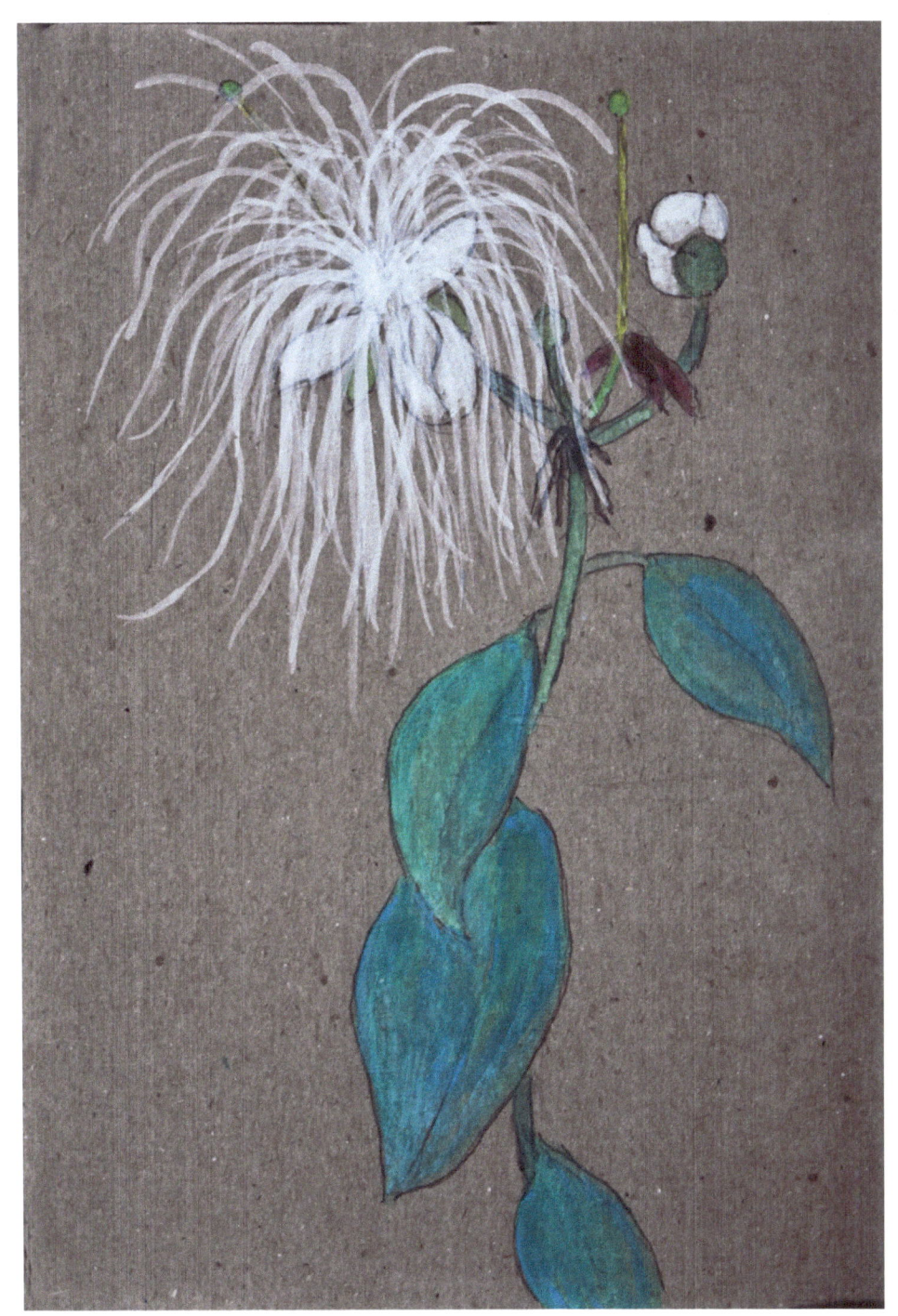

In February and March of 2012 I was doing mosaic mural projects with kids in Sri Lanka and India. When the projects were finished, my wife, Julie, came to India to do a little traveling and she brought a sketchbook for me. In the next ten days we traveled through the southern state of Tamal Nadu – hill country, nature reserves, and temple cities. I drew some of the incredible plants and flowers growing there.

All the sketches were done in pen and ink, and colored with watercolor.

My first trip to India was in 1980 when I was studying the sitar and went to Calcutta to study with my teacher's teacher, Gokul Nag.

So as a link between my visual art and my music I have put on each page a reflection on the god or goddess of some of the ragas that I play. These poetic descriptions are part of the ragmala paintings from old and ancient manuscripts.

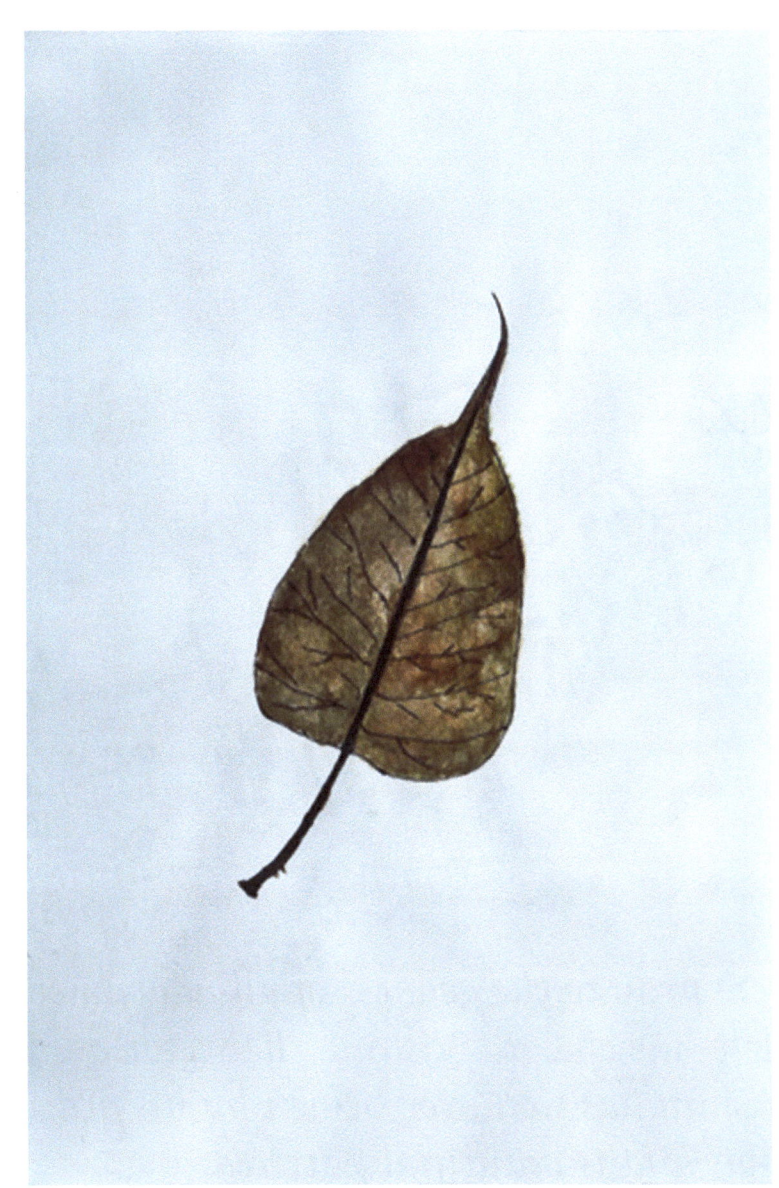

Yemen

Always I sincerely pray to the goddess of all adornment, Yemen, who sits on the left side of Lord Vishnu, the victor over the demon Madhu. Lord Vishnu has won over Yemen by his graces. She holds a drum in her hands and is beautifully attired.

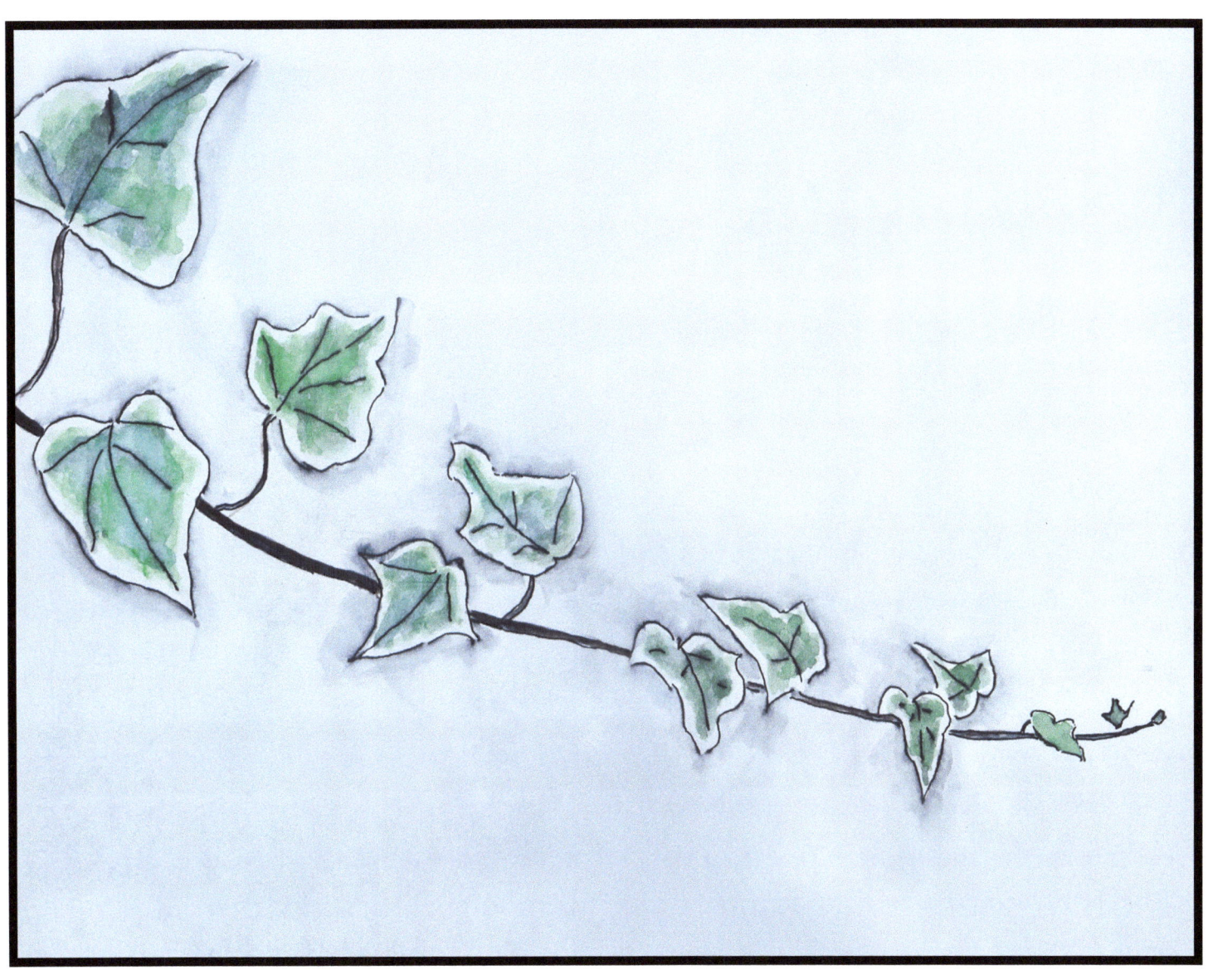

Bhupali

With a gleaming fair body anointed with fragrances, and high breasted, with her face radiant like the moon, Bhupalika is in great grief about the absence of her lover, and constantly thinks of him.

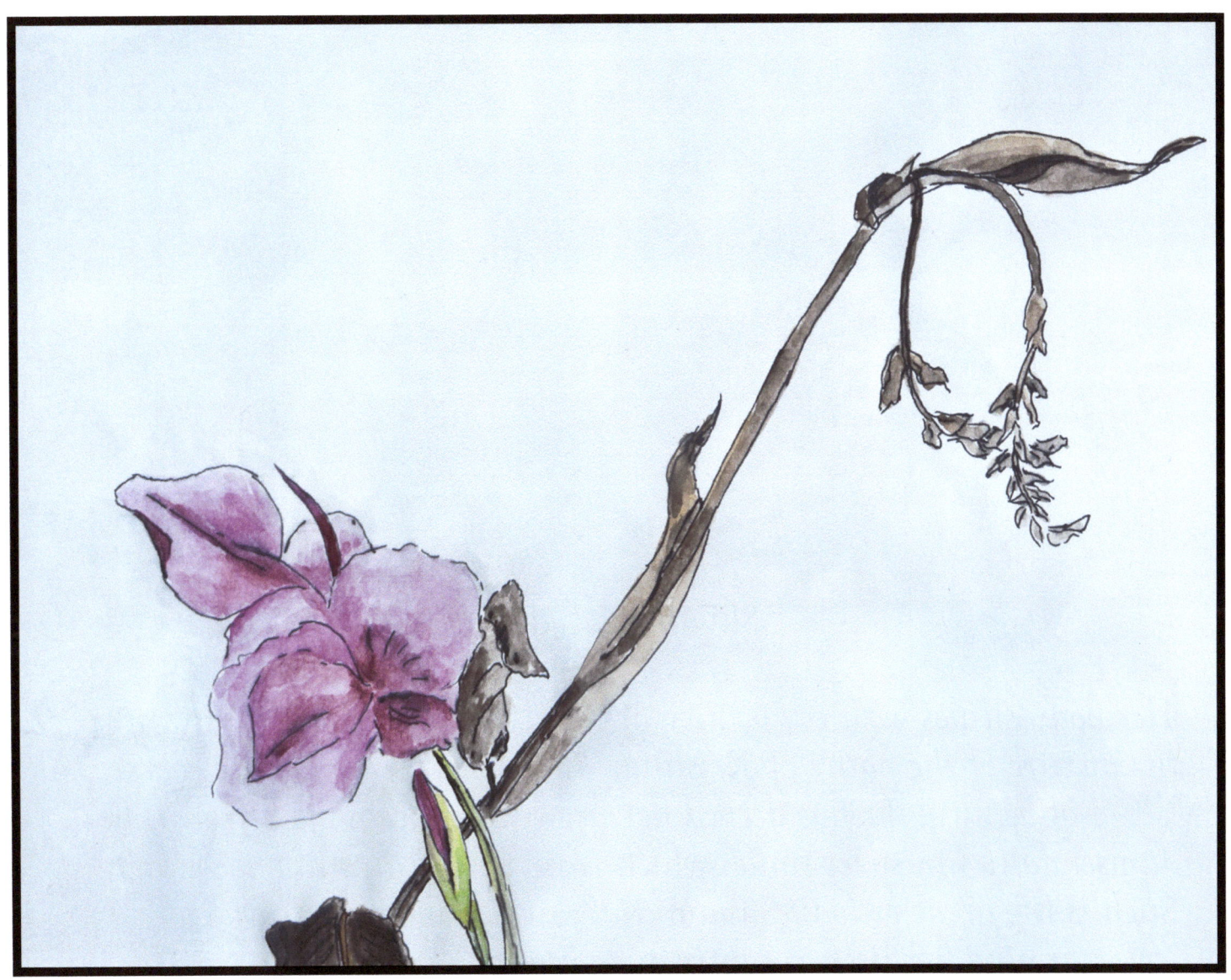

Shyam-Kalyan

Her body shines with the beauty of clouds; she has snatched away the picture of the figure of Krishna. The glitter of her yellow robes is full of beauty; she has decked her brow with specks of saffron. The damsel dallies in sweet smiles which raise new desires in one's heart. Such is the great melody Shyam-Kalyan carrying a wreath of jewels around her neck, a captivating beauty.

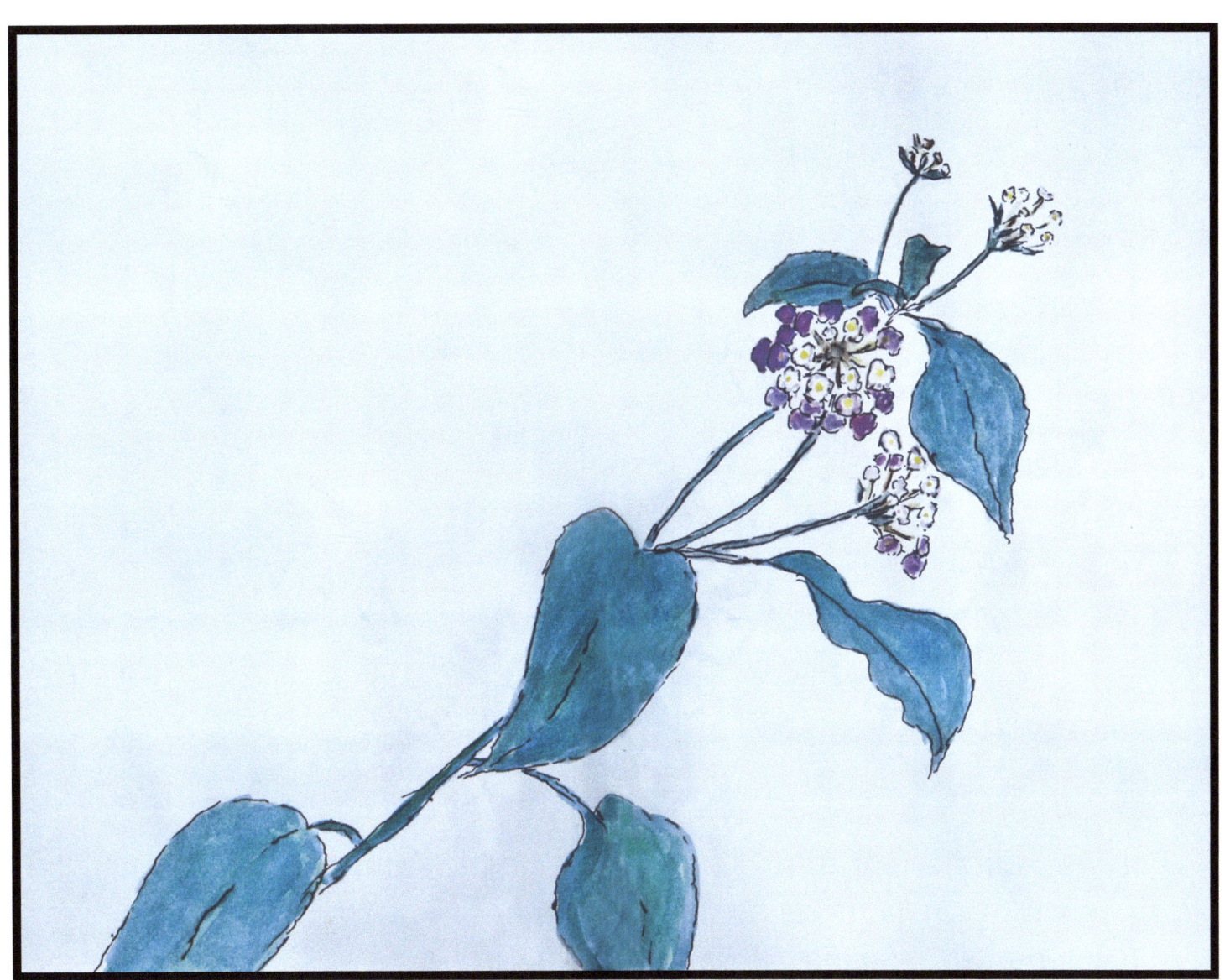

Khamaj

I always sincerely pray to Khambhoji who loves music, is restless and given to sensuous pleasures. Resting her left cheek in the palm of her hand, she scribbles in the ground with her toes.

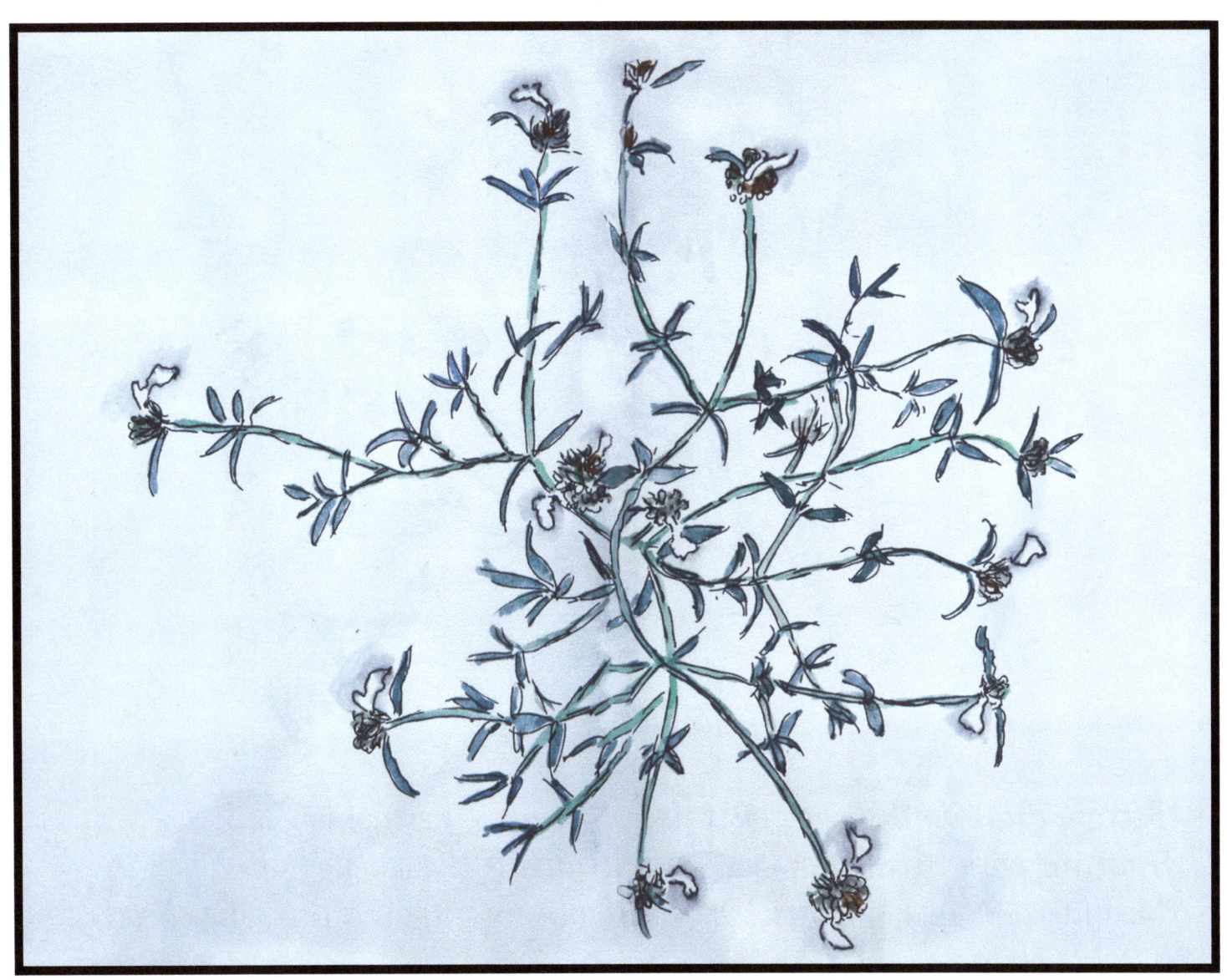

Jayjayvanti

Buxom and comely, with eyes like a gazelle's, her golden skin fragrant with divine flowers, Jayjayvanti is the consort of Megha-raga, god of rains. Drunken, playing upon a lute, she carols like a Kokila.

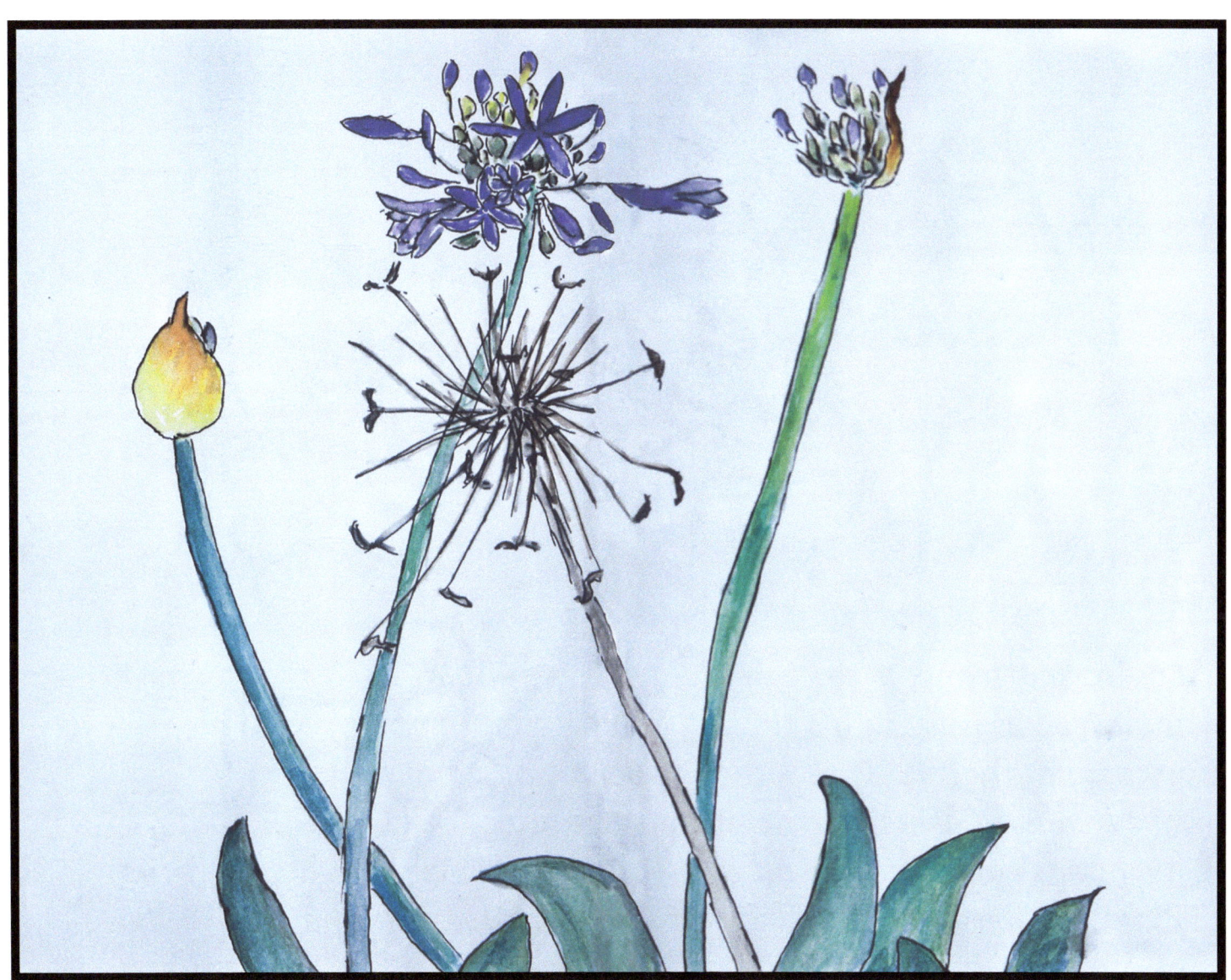

Bhairav

On his matted locks the Ganges sparkle and play; his large forehead is clasped by snakes; his three eyes offer emancipation from all woes; and around his face the ear pendants dangle. His body, smeared with ashes, carries ornaments provided by snakes; and his hands carry the trident and the drum which he beats. It is the incomparable picture of Sada-Siva. The melody of Bhairava shines as a great masterpiece.

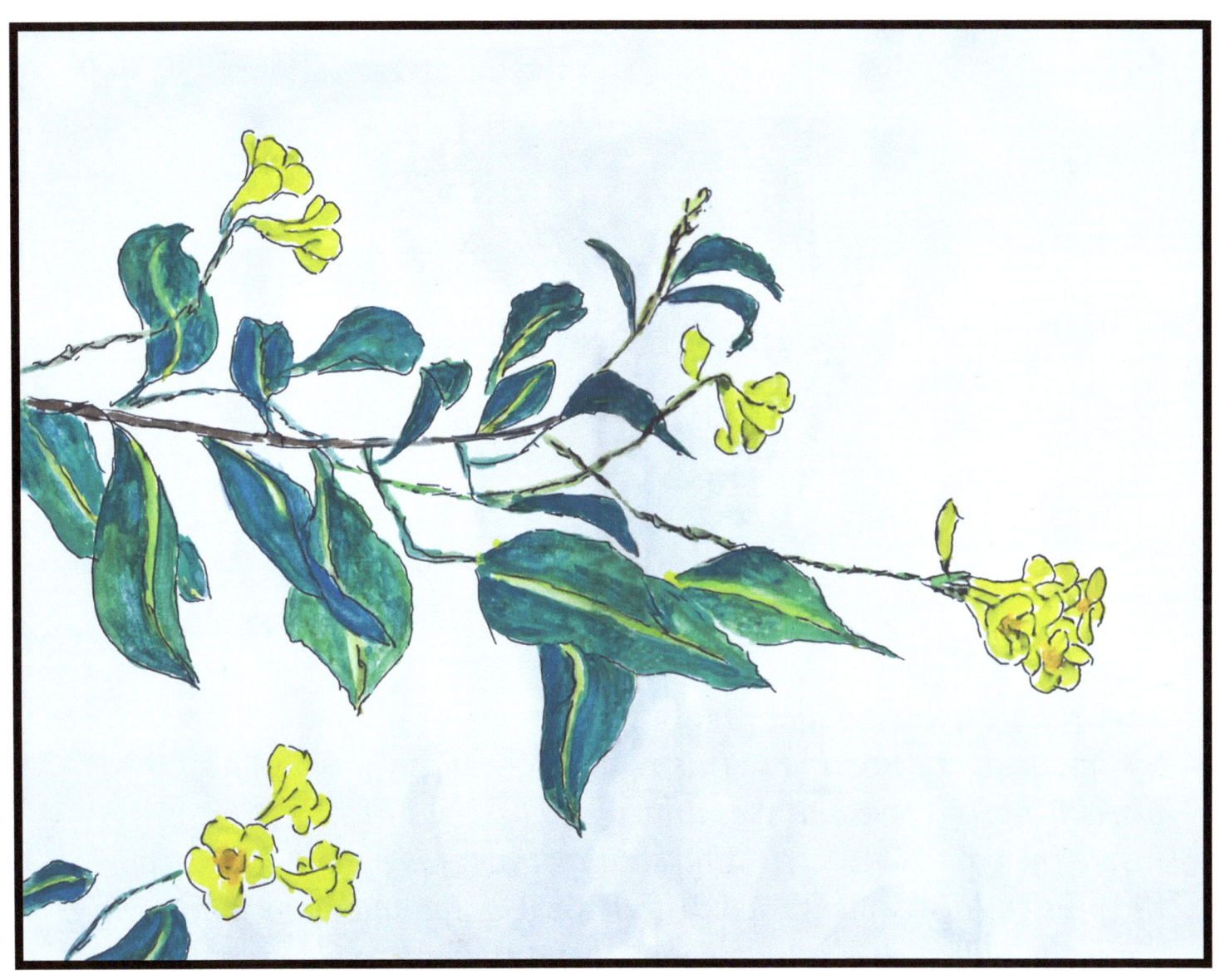

Shri-raga

Shri-raga is majestic and royal in appearance and you perceive his image upon listening to this raga. He spends the whole day in merriment and love and it is difficult to describe his secret pleasures inside the palace. An ascending string of notes is poured forth from the musical instruments, as if the River Ganga had risen in a flood. Even the skilled ones cannot comprehend the mysteries of this Raga.

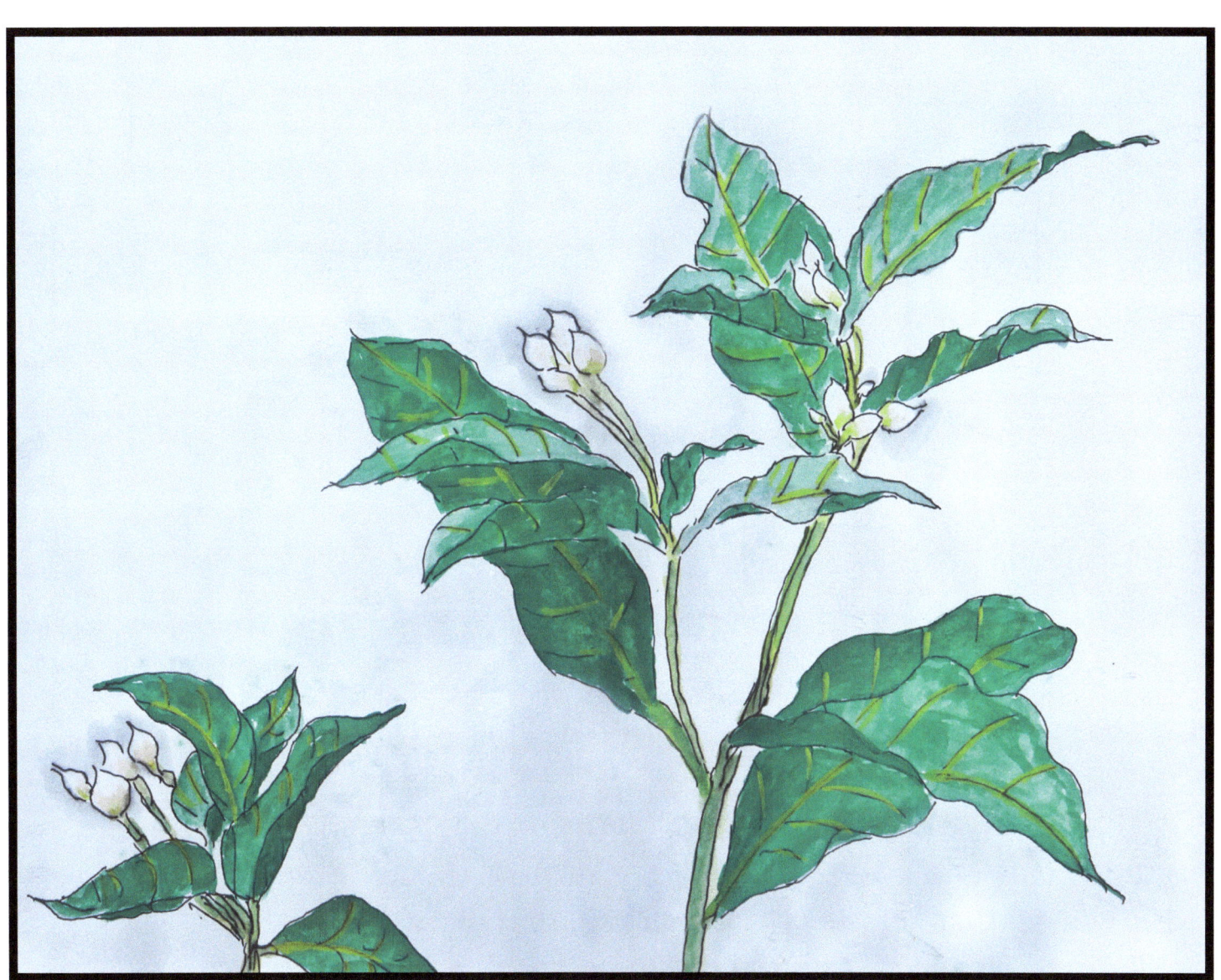

Vasant

Vasantika, beautiful like the blue lotus, wears earrings made of mango blossoms and the knot of her hair at the top is adorned with the tail-feathers of the peacock. Lovely and graceful, her beauty is enhanced by the glistening black bees circling around her.

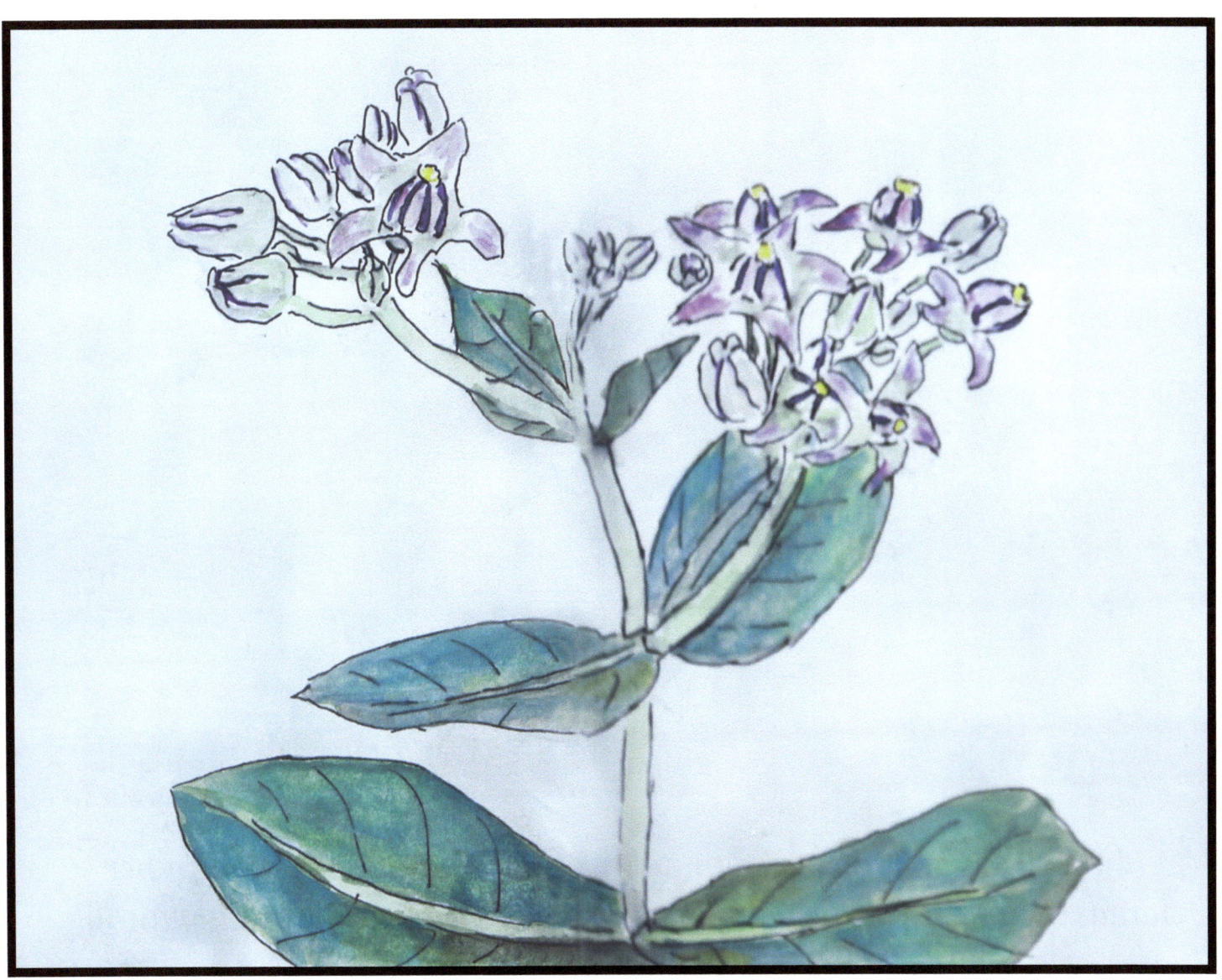

Lalit

Lalita, the mother goddess of music, holds a vina and a book in her hands. With beautiful eyes like red lotuses she is charmingly playful and speaks happily in a soft voice.

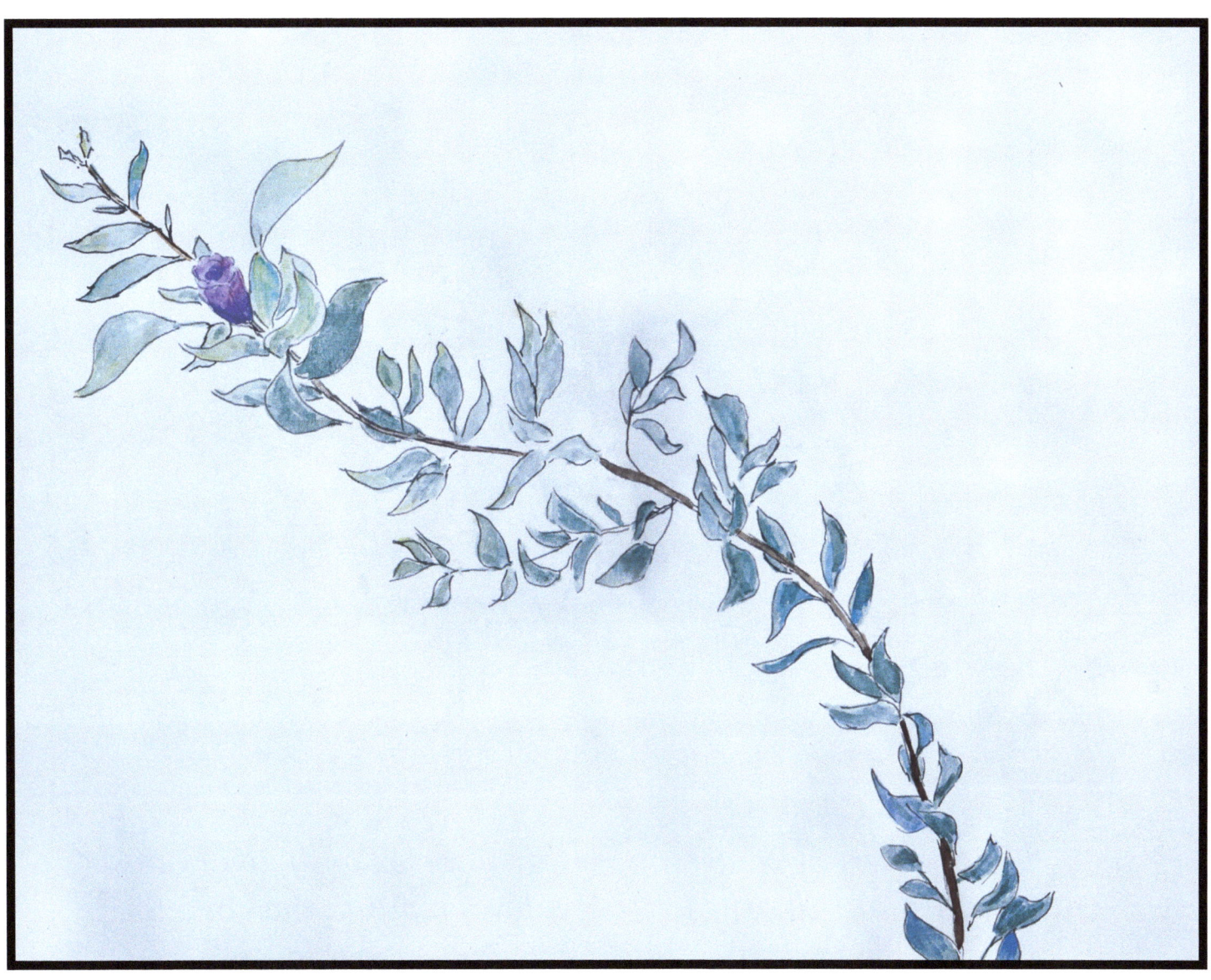

Bageshri

Bageshri, the consort of Malkouns, is fair complexioned, lovely and graceful. She has eyes like the lotus and loves playing the vina. She speaks charmingly when she is in the company of her lover.

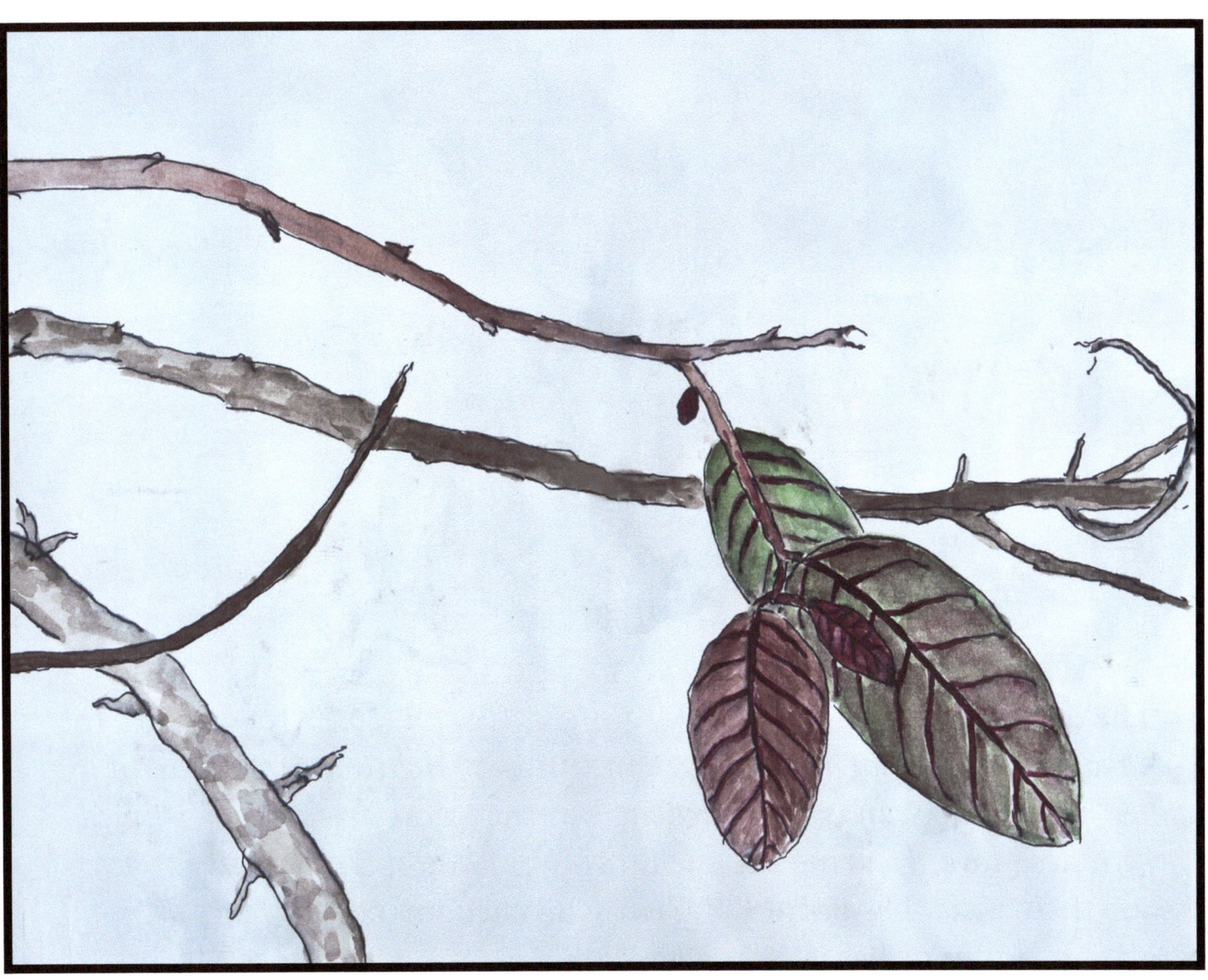

Todi

The almighty has made a wondrous creature in Todi. He appears to have spared no charm and grace in this act. Holding the nectar in her hands, she stands in a garden, and the world around her is filled with deep love. Hearing the enchanting sounds of Todi, herds of deer lose their way. The beauty of Todi is so enchanting that eyes drop after a glance at her.

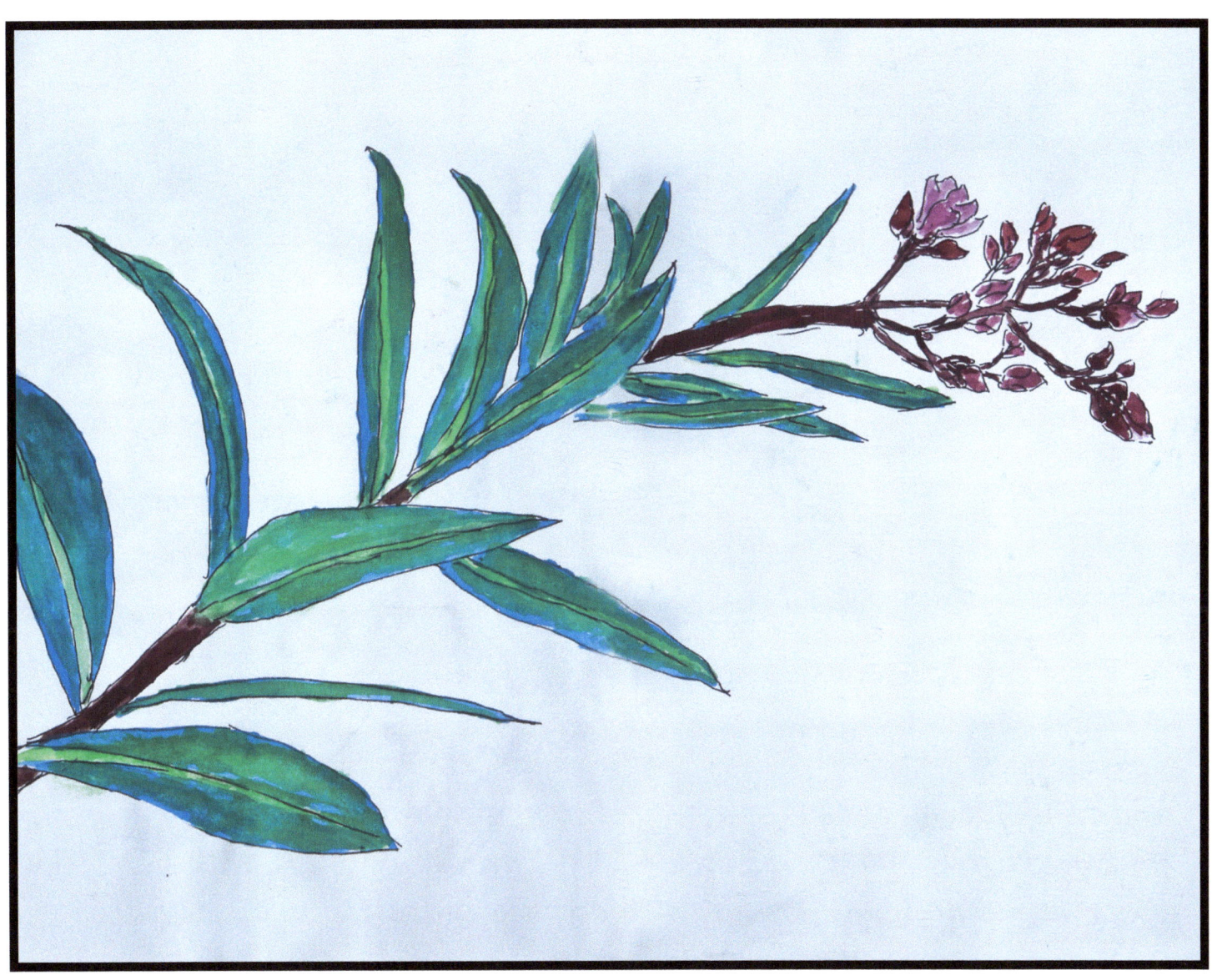

Desh

With the slow movement of a king of elephants, with eyes like that of a fawn, with a complexion like the lotus, with heavy hips, with her pleats dangling like a serpent, with a frame quivering like a delicate creeper, this comes into view, the Ragini Desh sweetly smiling.

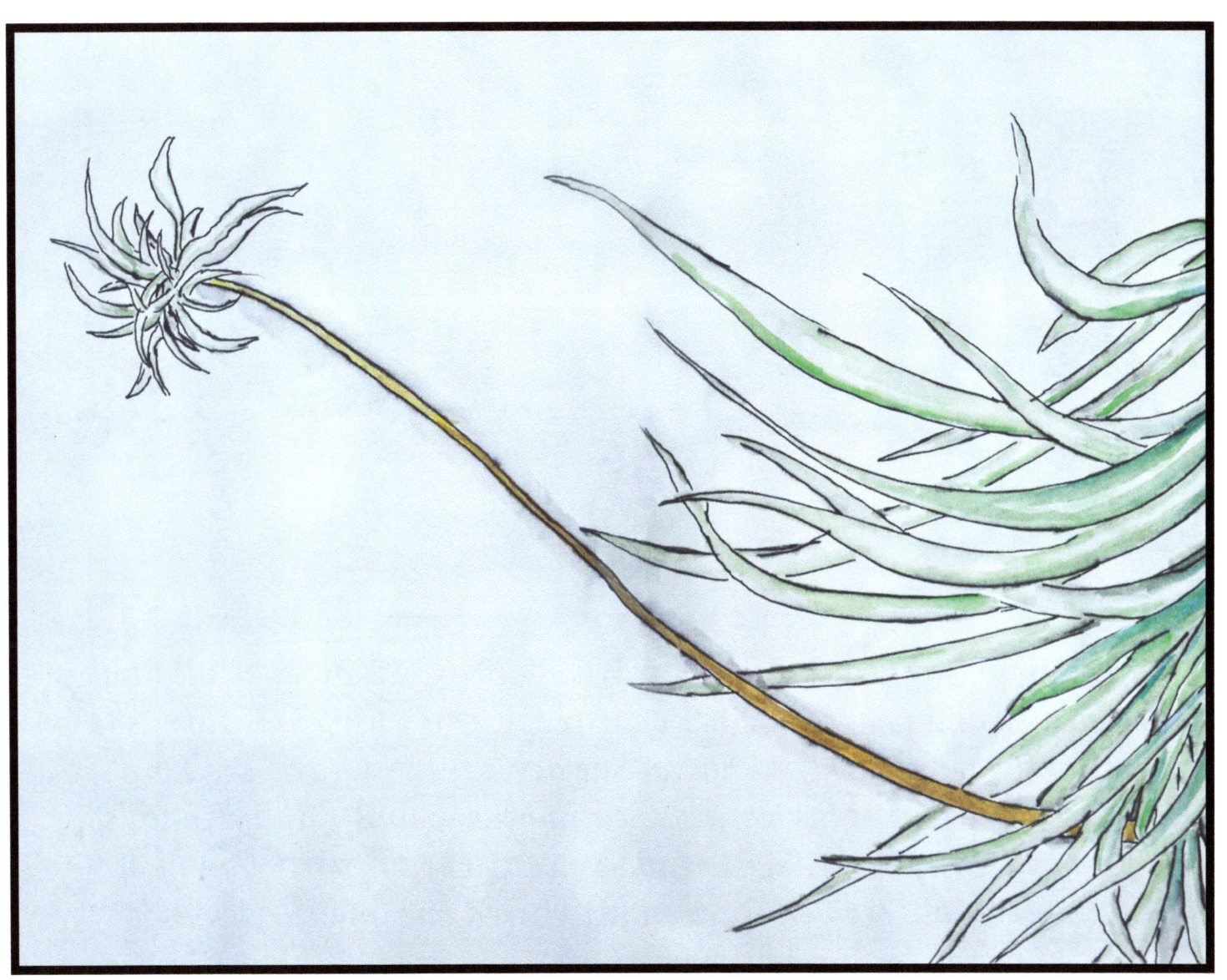

Bhairavi

This unmarried princess is Bhairavi. Bhairav was overwhelmed by her beauty and tempted by her charms. At this auspicious turn, she came to the temple of Lord Shiva. She devoutly prayed to the Lord for the fulfillment of her desires. Beating the drums with her hands, she sings praises of the Master and sincerely prays for the hand of Bhairav. She has set her heart on her chosen one and she does not forget him even for a single moment.

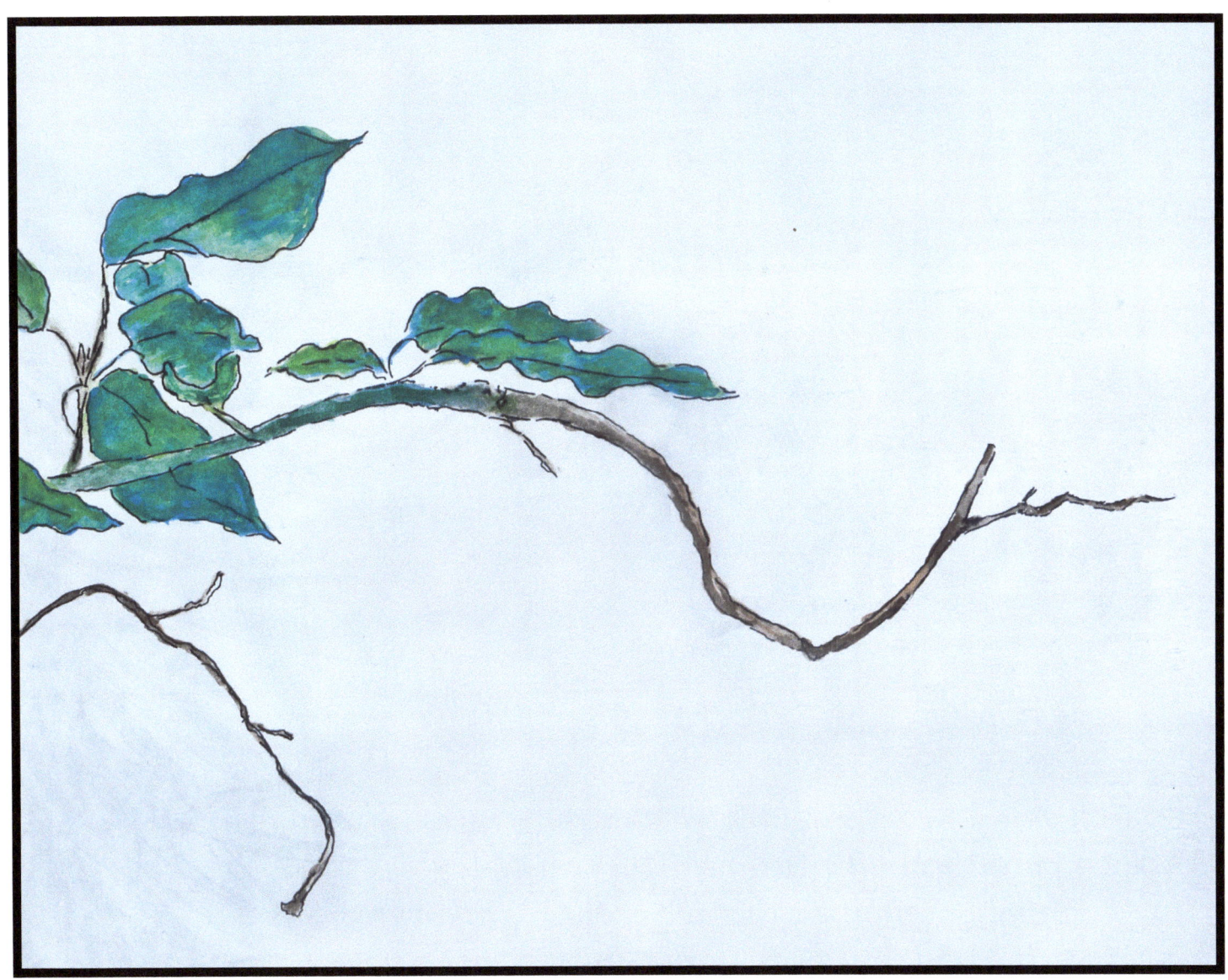

Darbari-Kanada

I think of Kanada as a dark woman, gorgeously dressed, with her long beautiful hair tied near the waist. Ever restless, she is exceedingly playful by the side of the Banyan tree. She is domineering and an expert in the gentle fights of love.

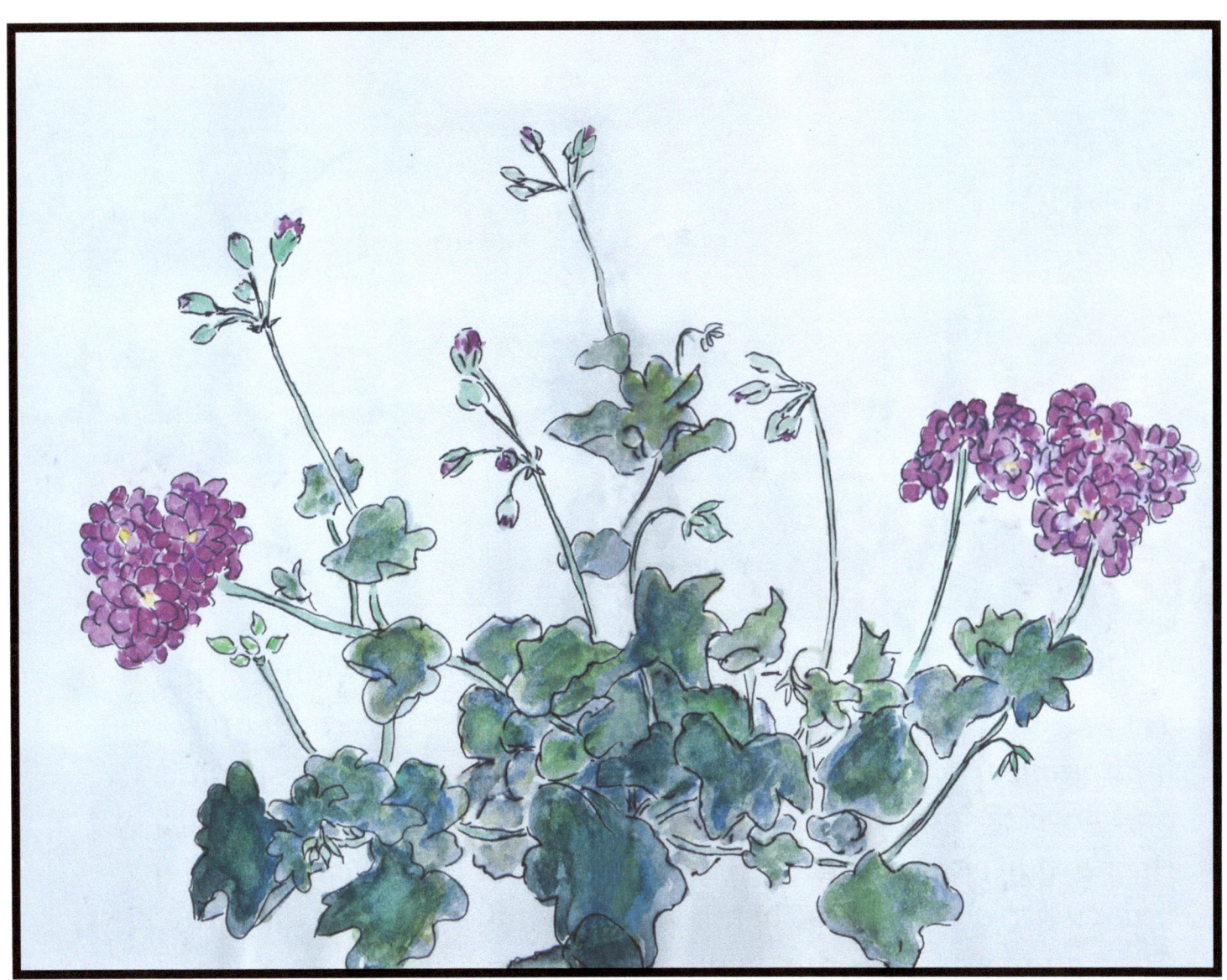

Malkous

Malkous wears a robe of blue; he holds a white staff in his hand. He wears on his shoulders a string of pearls; he is accompanied by a number of lady companions. With garlands on his shoulders and a white staff in his hand he is the very picture of the purity of the flavour of Love. He overpowers the heart of women, and by his beauty attracts the gaze of all. At early dawn he is up and seated. Hero and lover, he is contemplating his colorful exploits of love.

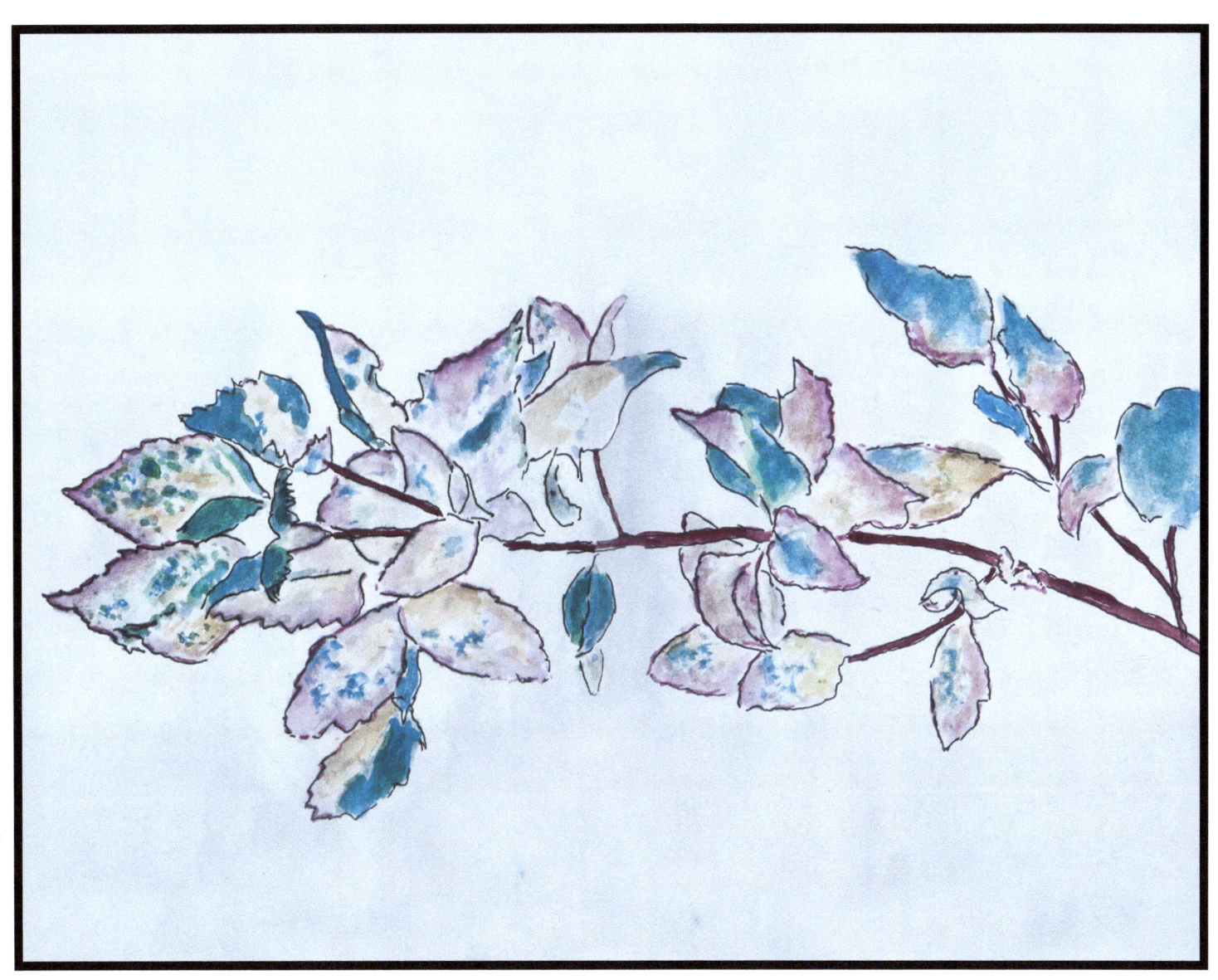

*Special thanks to all those who have taught and
inspired me in my music and my art*

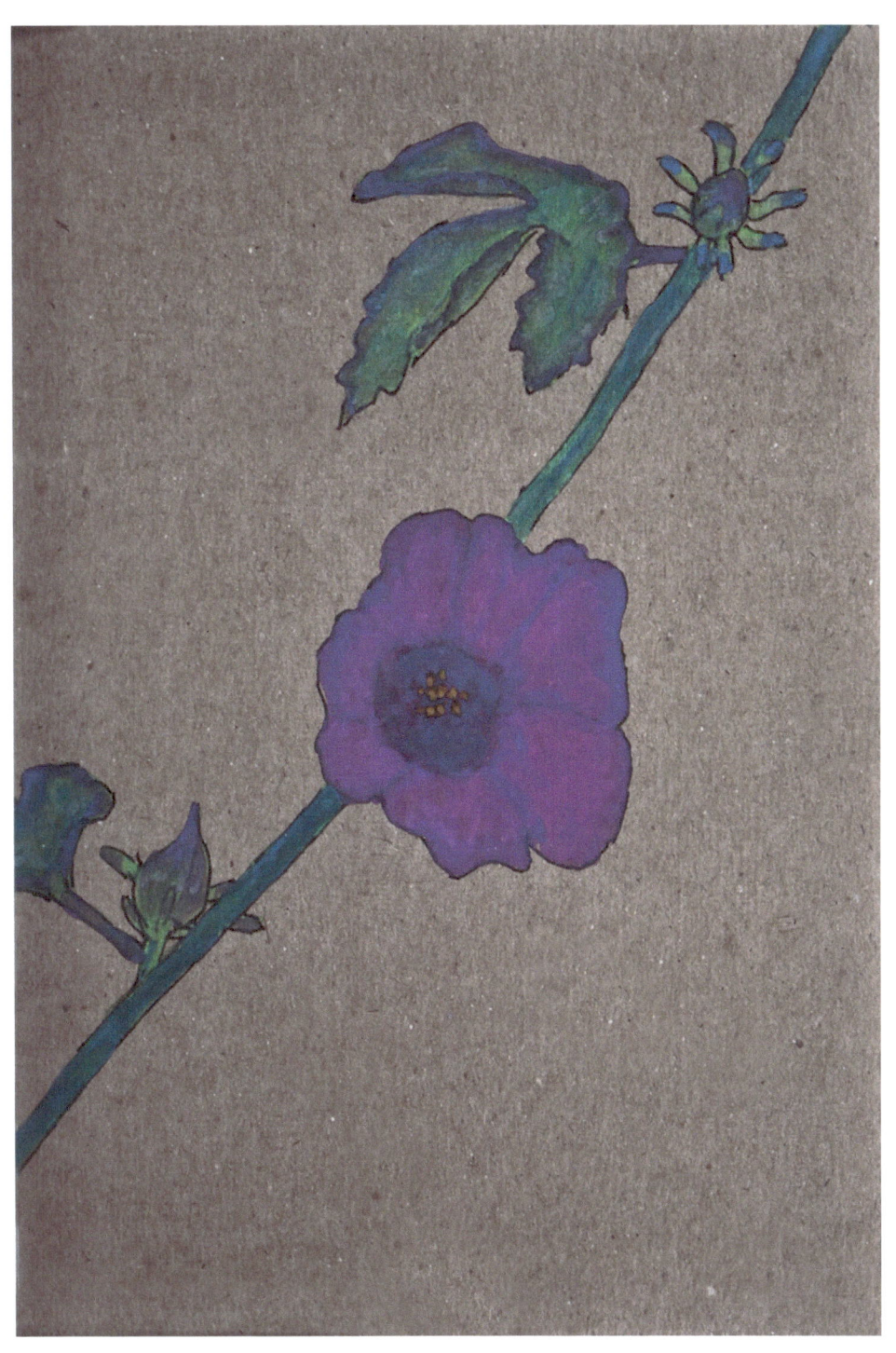

For Saraswati
goddess of knowledge, music and the arts

www.ingramcontent.com/pod-product-compliance
Lightning Source LLC
Chambersburg PA
CBHW050358180526
45159CB00005B/2067